contrasts: a glass primer

is modeled on an exhibition of the same name that runs from November 2006 to November 2009 at the Museum of Glass in Tacoma, Washington. *Contrasts* represents our mission to focus exclusively on objects made of glass and to reach and educate new, nontraditional audiences in that medium. The exhibition adopts the concept of a primer—a book that covers the basic elements of a subject—and seeks to allure first-time museum visitors. Through imaginative and witty groupings of glass objects, guest curator Vicki Halper has created an exhibition that is thought provoking, intelligent, and visually stunning.

The beautiful clarity of *Contrasts: A Glass Primer* is an open invitation to enjoy art, and the creative juxtaposition of objects and words serves as a foundation for contemplating, understanding, and appreciating the magical medium of glass.

On behalf of the Museum's Board of Trustees and staff, I sincerely thank all of the institutions and individuals who have made this exhibition possible through their support and generous loans of these wonderful objects.

—**Timothy Close, Director/CEO**
Museum of Glass

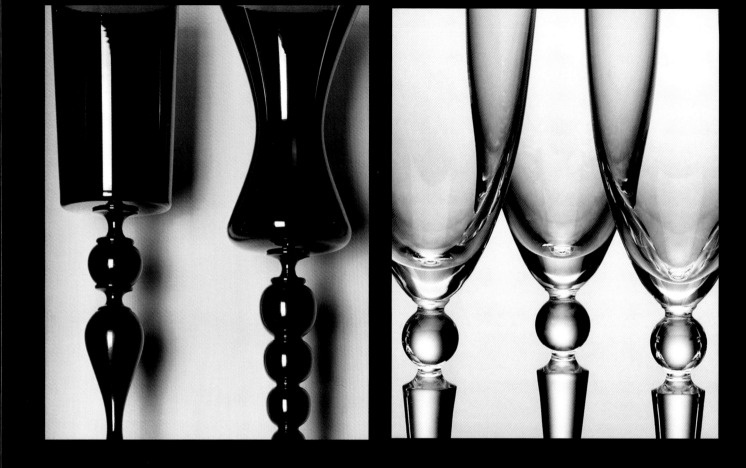

VICKI HALPER

contrasts
a glass primer

MUSEUM OF GLASS, TACOMA
in association with
UNIVERSITY OF WASHINGTON PRESS
SEATTLE AND LONDON

I like it.

I don't like it.

**Are there other ways
to think about works of art
before this rush to judgment?**

Try description, the basis of appreciating art.
It precedes understanding and evaluation. In describing an object we pause to take a careful look. We notice details that we didn't see at first. We make note of colors, textures, shapes, and the interrelationship of parts. The more we see, the more we are likely to decipher the meaning of the piece and the intention of the maker. The more we see, the more likely we are to understand why we like or do not like an object, or to change our opinion.

Contrasts: A Glass Primer presents glass objects and words to describe them. Some of the words are associated with glass in particular; others can be applied to all kinds of objects; a few are technical. The objects in *Contrasts* are paired, as in a child's book of opposites, to highlight particular characteristics of each piece, but the objects differ from each other in many ways. Different descriptive words could be used too. The idea is to sharpen the quality of vision brought to each work while also imparting some understanding of the nature of the medium, its history, and the choices artists make as they use it.

natural

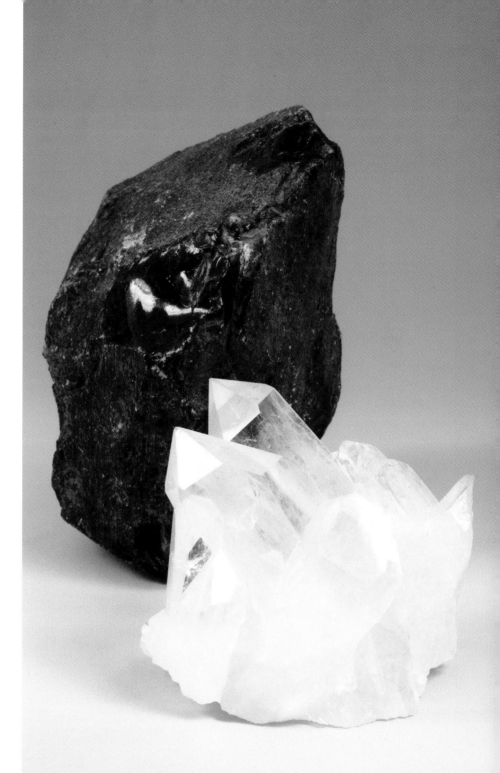

Geologic glass is formed by the effects of extreme heat and rapid cooling on sand or stone. Obsidian, for example, is formed by volcanic action; fulgurites are formed when lightning strikes sand; and tektites are the result of meteors hitting the earth.

Rock crystal, a form of quartz, shares the translucency of glass, but has a crystalline structure; true glass does not.

One extraordinary organism, the *Euplectella*, or glass sponge, has a tubelike skeleton formed from silica, the major ingredient of glass.

Euplectella aspergillum (skeletal detail, left); obsidian (top), quartz

fabricated

Glass is an artificial product composed of chemicals melted together under high temperature. There are countless recipes for making glass, but all must include a high proportion of silicon dioxide, derived from sand or quartz, and most include fluxing agents, such as soda ash and limestone, to lower the melting point. Other chemicals are added to the recipe to provide clarity, brilliance, flexibility, color, and additional properties desired by artists or industry. Many makers of glass objects begin with "batch" or premixed chemicals that have been formed into glass pellets, ready for melting in the furnace.

Common glass ingredients in relative proportion to each other

SODA ASH
(sodium carbonate)
Na_2CO_3

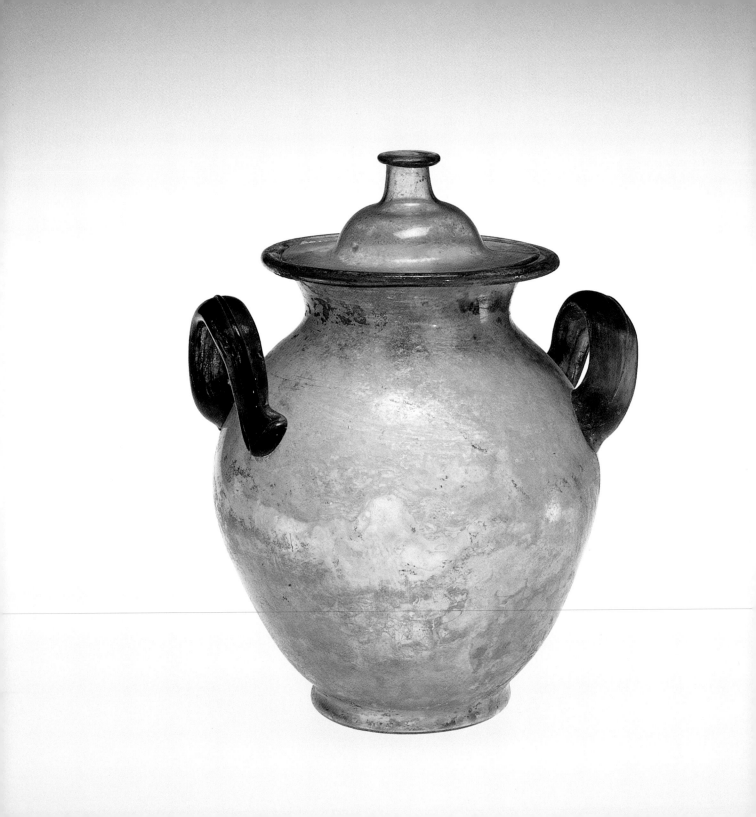

hot

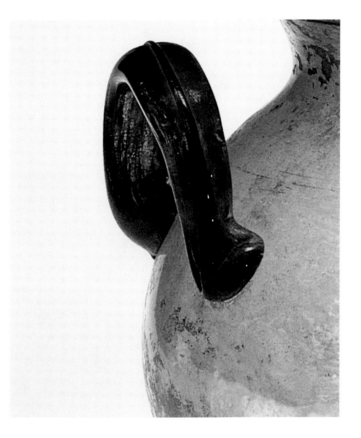

Glass that is manipulated just after leaving the furnace in a molten and fluid state, at about 2000°F, is called hot-worked glass. Blowing, the technique most closely associated with hot glass, was invented by the Romans in the first century A.D. The hollow interior and draped handles of this funeral urn are signs that the vessel was blown and worked hot.

Jar with Two Handles and a Lid, Roman Empire, 1st–2nd century A.D.

warm

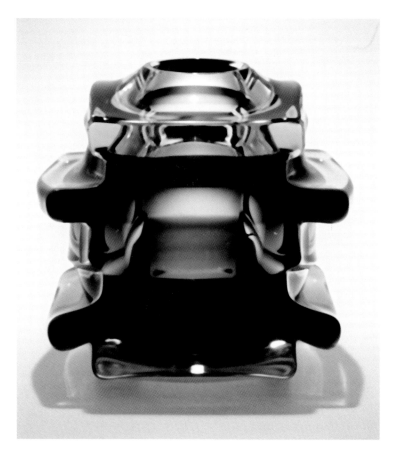

Glass whose shaping occurs at lower heat, usually under 1000°F, is worked warm. In kiln-formed glass, elements that are assembled at room temperature are slumped (heated until bent) and fused in a kiln (oven). Tom Patti's softened stack of plate glass sheets is an example.

Tom Patti, *Solar Gray Purple Compound with Planes*, 1981–84

In kiln casting, glass bits are first placed in a mold. The mold is then moved into the kiln, where the glass melts and takes the shape of the mold.

In flameworking, glass rods, tubes, and sheets are heated with a tabletop flame and then manipulated to change their shape. The flame may reach the temperature of a furnace, but its effects are localized.

cold

Cutting, grinding, polishing, engraving, and painting are some of the techniques used on room-temperature, or cold glass. Sidney Hutter cuts and glues together flat pieces of glass to make a vase-like sculpture with crisp edges.

Sidney Hutter, *White House Vase #6*, 1995

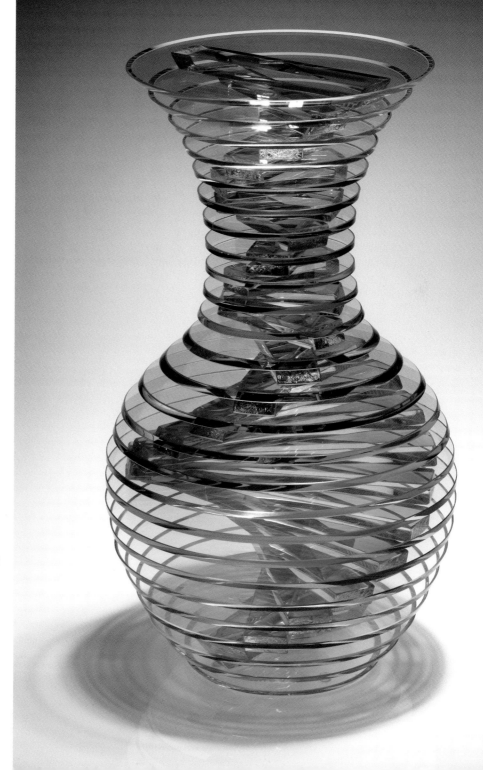

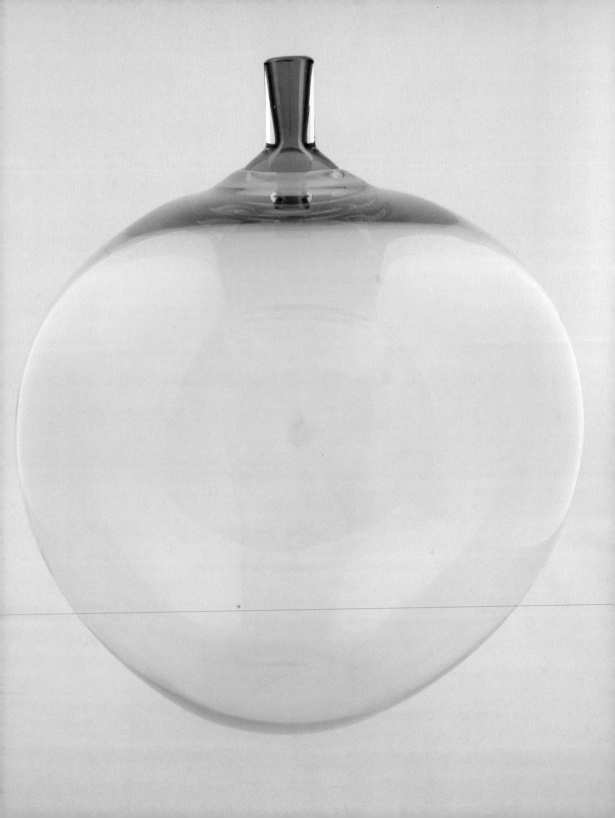

Transparency permits glass to reveal while it separates.

translucent/opaque

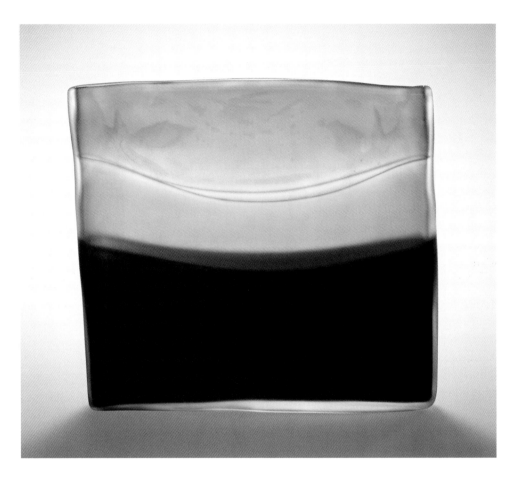

When light, but not images, can pass through glass, the glass is called translucent. Laura de Santillana creates a landscape-like abstraction by controlling both the amount and the color of the light that is transmitted through her work.

Laura de Santillana, *Sun Chariot*, 2001

Adding ingredients to a basic glass recipe can make glass as opaque as granite. Glass is prized for many qualities other than transparency. Some artists may value its malleability or density, while chemists may treasure its stability and resistance to corrosion.

Richard Marquis, *Marquiscarpa #99–16*, 1999

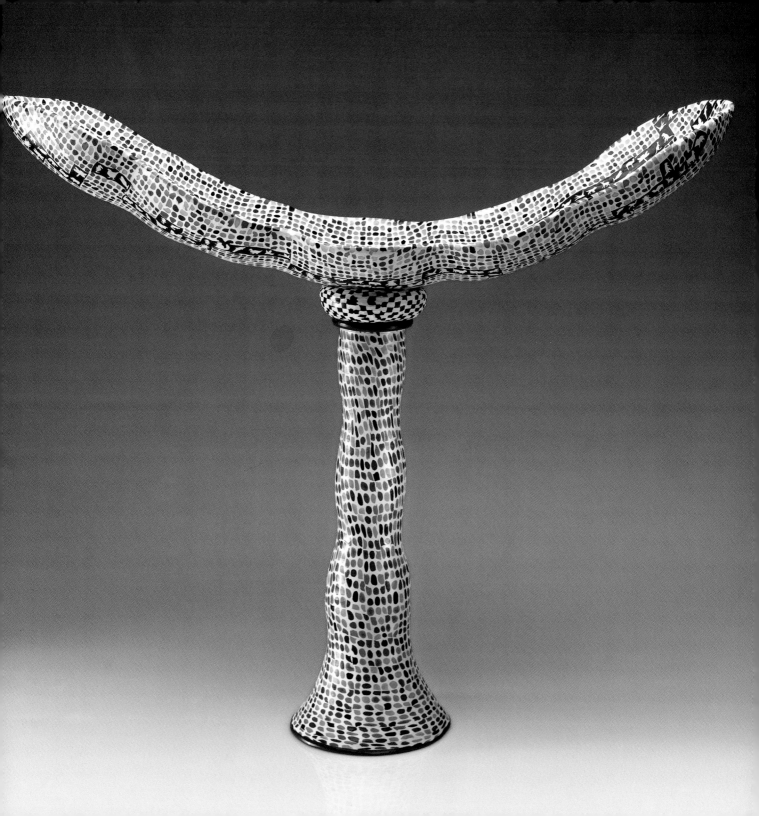

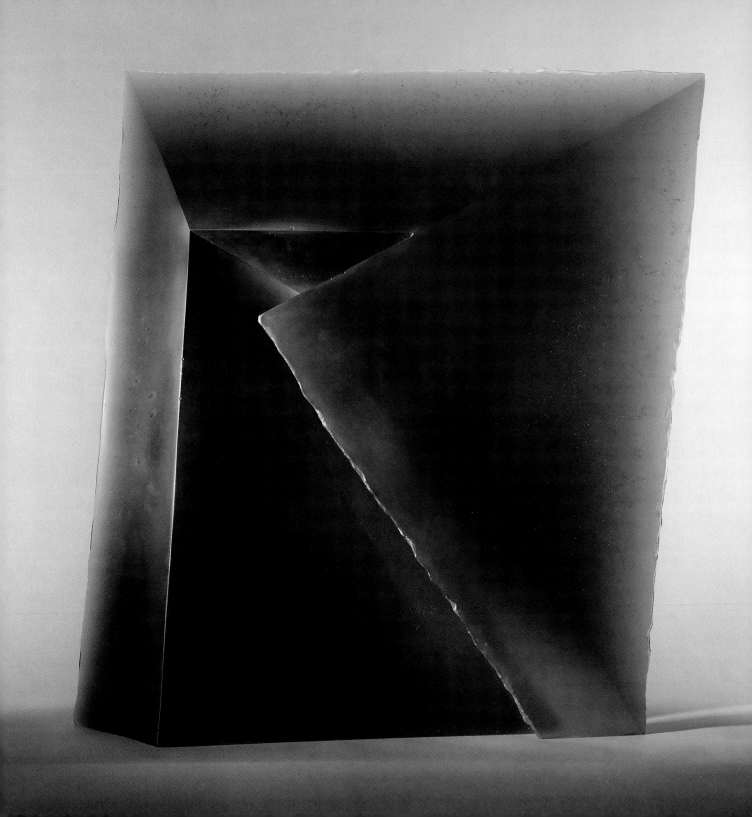

rigid/fluid

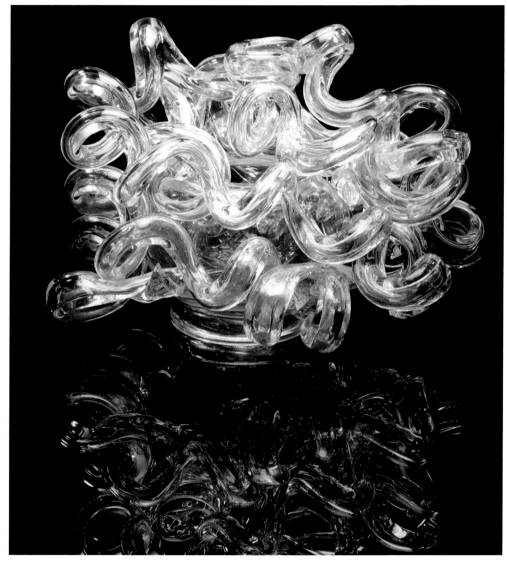

Dale Chihuly, *Crystalline Clear Venetian with Clear Coil*, 1991

Diagonal is massive, angular, and mysterious. The density and precision of this sculpture is achieved by casting, grinding, and polishing the glass. Light and color are controlled by varying the thicknesses of the glass and by exacting placement of the voids.

Dale Chihuly's work seems as free as Jaroslava Brychtová and Stanislav Libenský's is restrained. The fluidity, immediacy, and even lightheartedness of this curly headed, blown vessel are hallmarks of his style. Chihuly's gaffers (glass blowers) must work precisely and fast, before the glass cools and becomes inflexible.

See also hot/warm/cold

Jaroslava Brychtová and Stanislav Libenský, *Diagonal*, 1989

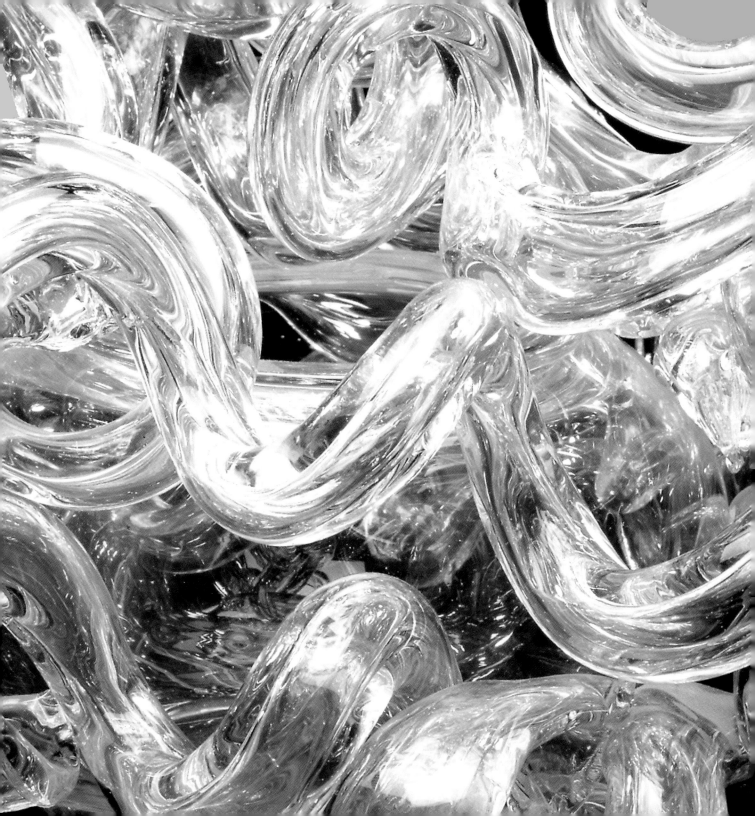

thick

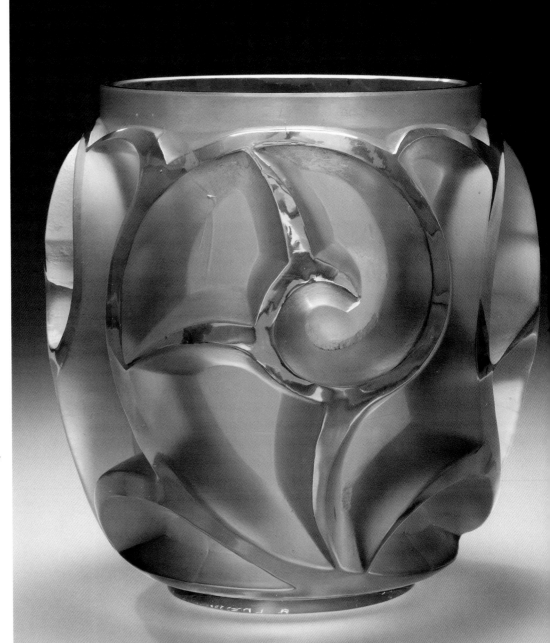

As glass gets thicker, it becomes less transparent. Colors become increasingly dark, and deep grooves can be molded or cut into the surface. This piece is substantial, not dainty.

René Jules Lalique (designer), *Tourbillons*, R. Lalique et Cie., 1926

thin

Glass is closely linked with delicacy for many people. Thin glass emphasizes the medium's transparency and fragility. Here the airy pattern in the glass is made by overlaying patterned glass rods onto the gather (ball) of hot glass that is to be blown.

See also transparent/translucent/opaque

Brigitta Karlson and Ove Thorsson (designers), *Reticello Bowl*, Venini Glassworks, 1972–74

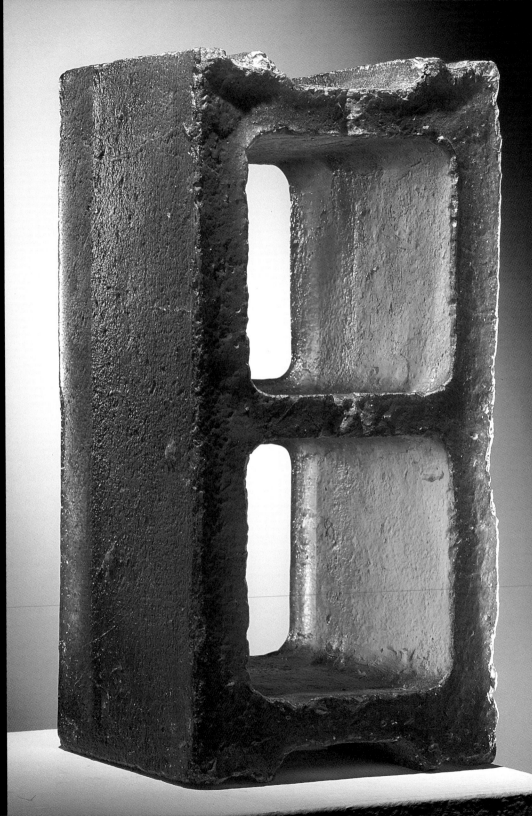

Robbie Miller, *Block*, 2000

heavy

Heavy as a brick.

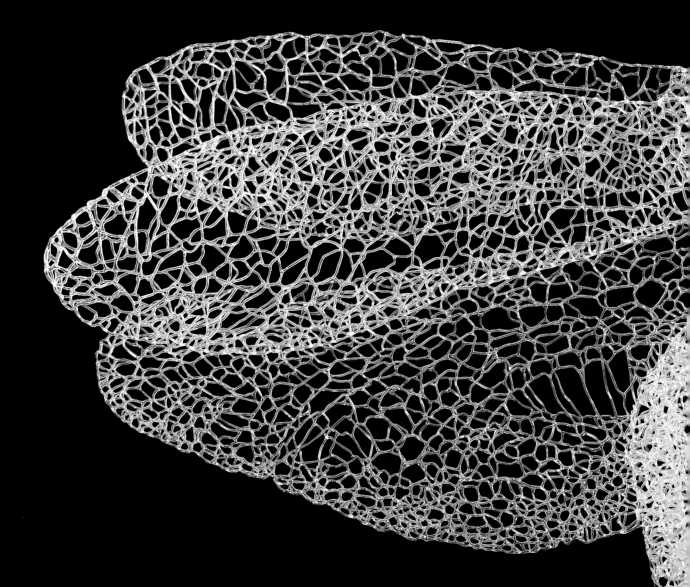

Light as a fly.

light

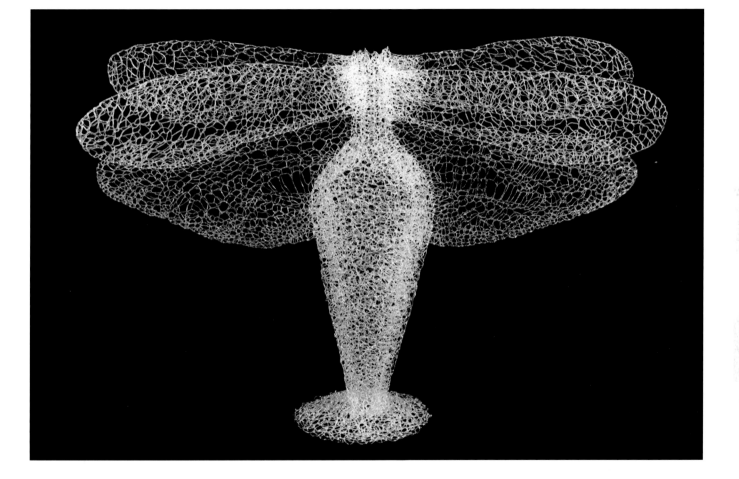

painted

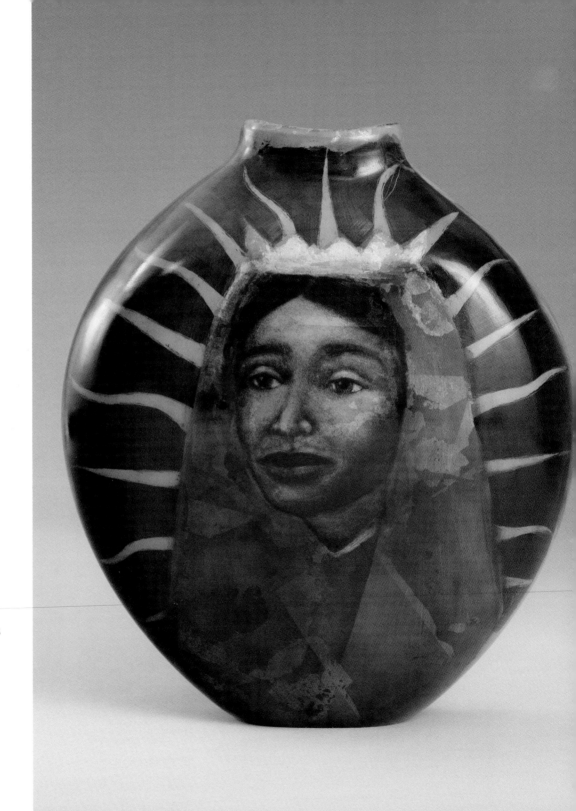

Enamel is made of ground glass and mineral pigments and can be used like paint to decorate the surface of cold glass. When enameled glass is returned to the kiln for additional firing, the heat fuses the design to the vessel and makes it permanent. This picture will never fade.

Walter Lieberman, *La Reina de las Campesinas*, 1995

engraved

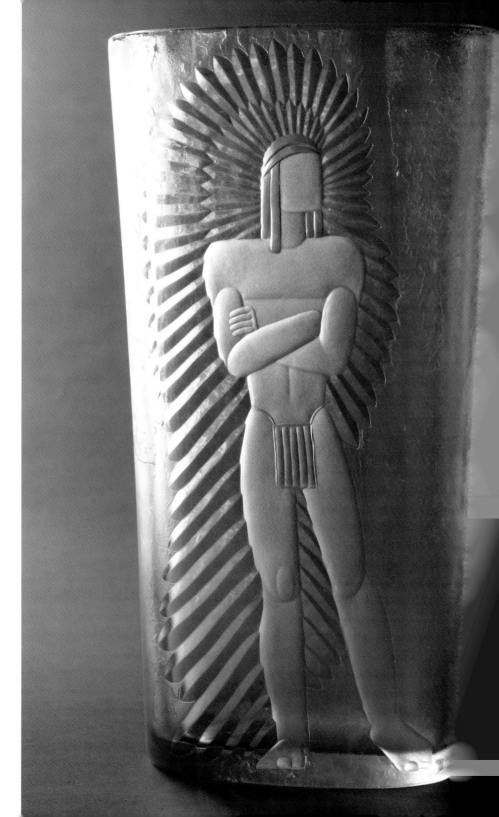

Artists use hand tools, acid, and grinding wheels to cut into the surface of cold glass. The result can be as delicate as a scratched line or as modulated as a relief sculpture. The design can be seen without the addition of color.

See also hot/warm/cold

Vicke Lindstrand (designer), *Indian Chief Vase*, Orrefors, 1937

form

In *Water Catcher*,
Flora Mace and Joey
Kirkpatrick have
sculpted rather than
drawn a figure. Its face
is three-dimensional,
with some enameled
details on the surface.
The figure raises a
vessel whose shape
and properties as
a container are
emphasized, rather
than its surface.

Flora C. Mace and
Joey Kirkpatrick, *Water Catcher*,
1984

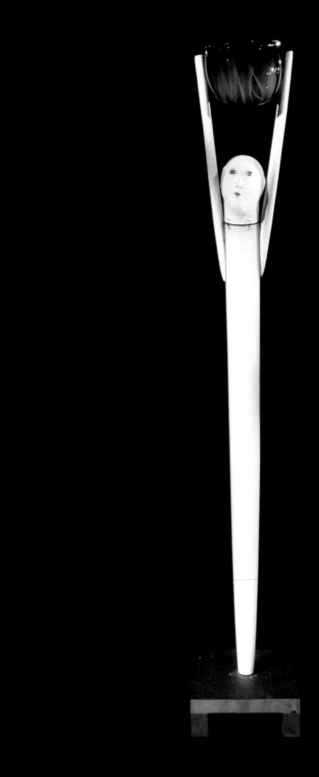

surface

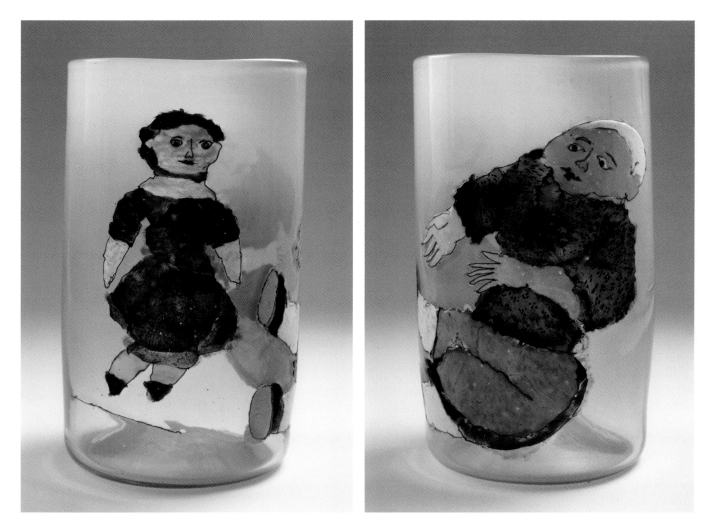

An enameled vase is like a painted canvas in the round. The glass vessel,
like a painting's fabric backing, is a blank background waiting to be embellished.

See also painted/engraved

Flora C. Mace and Joey Kirkpatrick, *Doll Drawing* (two views), 1981

free-blown mold-blown

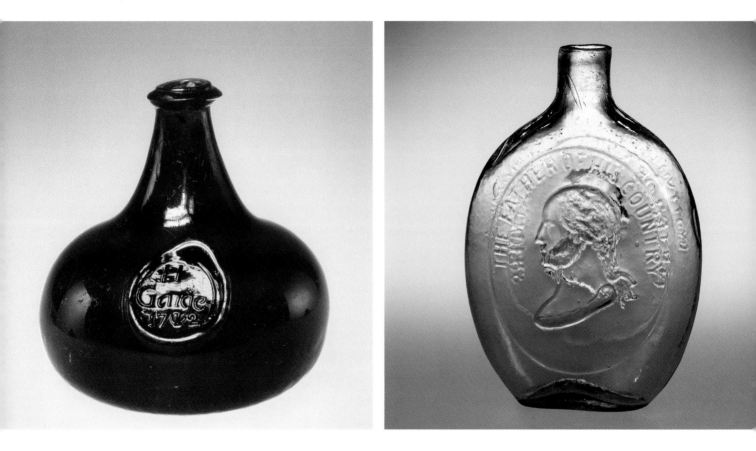

A glassblower's breath and hand tools alone shape free-blown objects. Although a highly skilled artisan can make many similar forms, they are rarely identical.

Wine Bottle with Seal of H. Gaige, 1712

When consistency is desired, as in a series of bottles meant to hold the same amount of liquid, glass can be blown again and again into a mold shaped of wood, metal, plaster, or graphite. Mold-blowing also allows objects with complicated shapes or detailed ornamentation to be made quickly in multiples.

Flask with Portraits of George Washington and Zachary Taylor, Dyottville Glass Works, about 1847–48

machine-blown

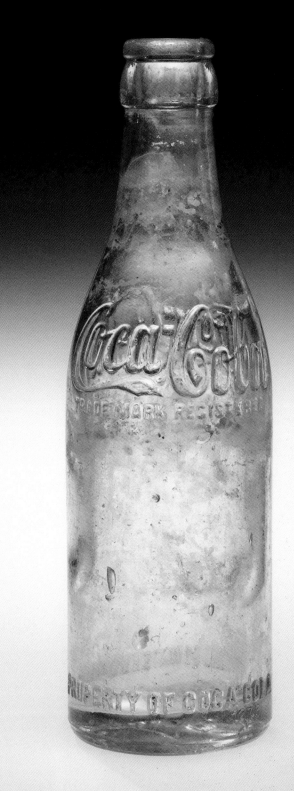

Automated methods of making huge numbers
of identical glass bottles were perfected between
1880 and 1920. This early Coca-Cola bottle was
made without a human glassblower.

See also factory/studio

Straight-Sided Coca-Cola Bottle, 1910–19

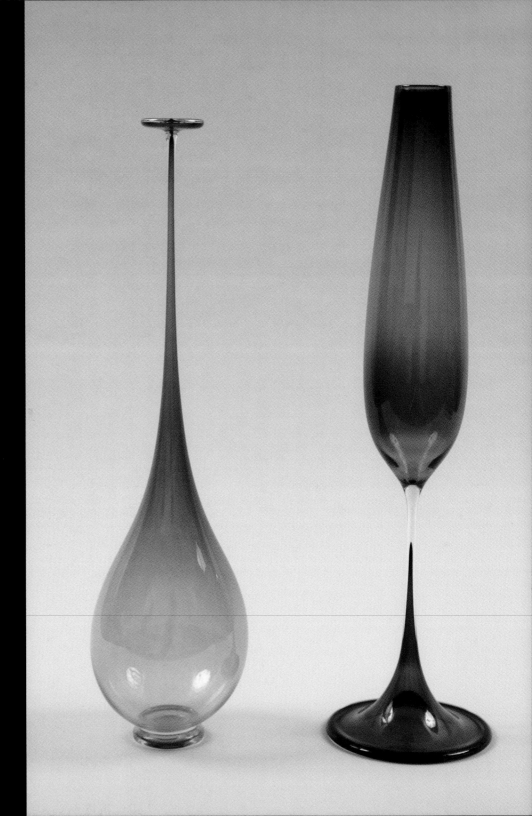

Landberg (designer), *Tulip Goblet
Vase*, Orrefors, about 1957

factory

Until the mid-twentieth century, virtually all nonindustrial glass was produced in small factories by teams of artisans. The designer who conceived the product never worked directly with the glass. Pieces of extreme beauty and sophistication were made this way, and the names attached to the work were those of the designers— Lalique, Venini, and Landberg, for example.

studio

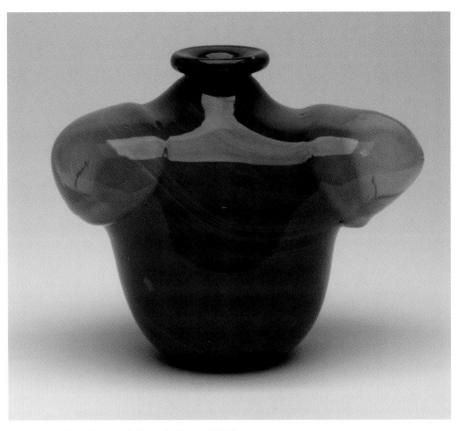

Harvey K. Littleton, *Vase with Expanded Prunts,* 1965

In the 1960s a few people in the United States began to ask if glass could be blown by artists working alone using furnaces designed for private studios rather than for factories. Harvey Littleton tested this idea at a workshop he organized at the Toledo Museum of Art in 1962, a date that marks the beginning of today's Studio Glass movement. (Pilchuck Glass School in Stanwood, Washington, was founded nearly ten years later, in 1971.) The early results of studio glassblowers were exhilarating but crude when matched against European standards.

See also creator/designer

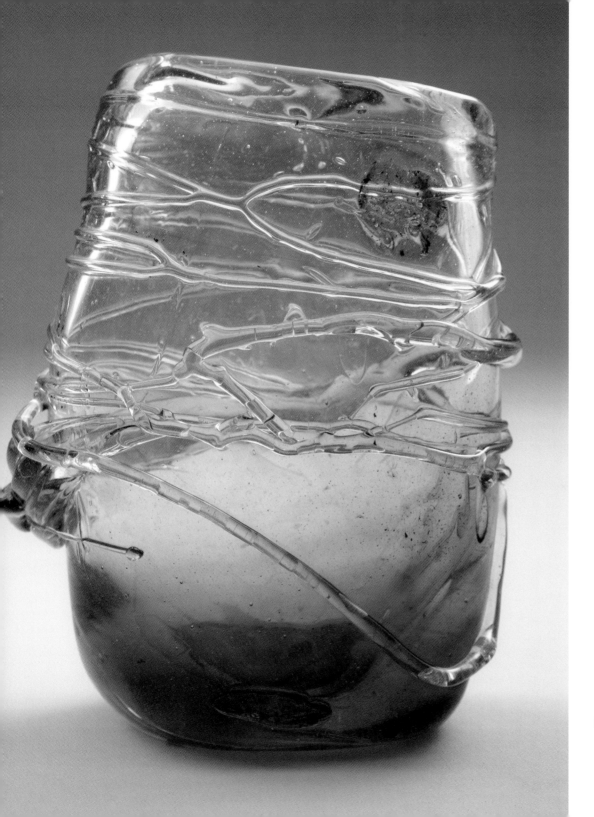

Russell Day, *Untitled*, 1965

creator

When Dante Marioni blows goblets for himself, he is inspired by historic examples of Venetian glass and governed only by artistic considerations. He has no need to modify his designs for the production of multiples or test their commercial viability through focus groups.

Dante Marioni, *Yellow and Blue*, 2002

designer

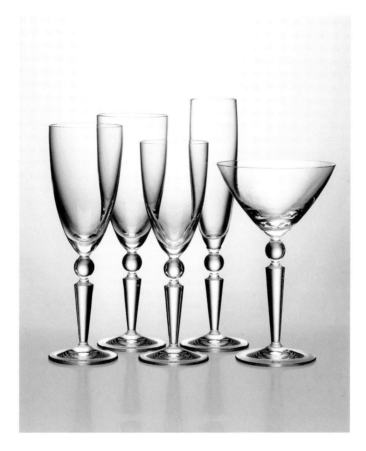

When Marioni designed these goblets for the manufacturer Steuben, he presented the company with a series of sketches. Steuben then made samples for testing by focus groups before putting the chosen goblets into production. Marioni never touched the glass.

Dante Marioni (designer), *Goblets from the Counterpoint Collection*, Steuben Glass, 2003

useful

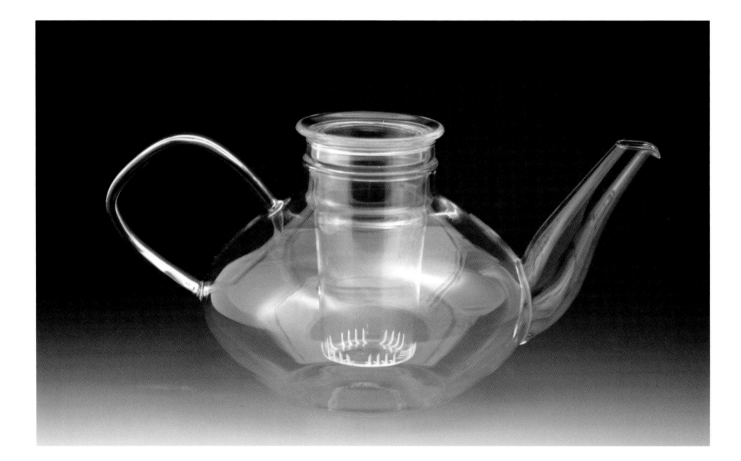

Wilhelm Wagenfeld, like other designers at the Bauhaus school in Germany, equated beauty with function. Heat-resistant glass is used in his famous teapot, designed in 1932. Tea leaves are placed in a pierced glass basket that can be easily removed before the tea becomes bitter. The level of water is always visible, the spout pours precisely, and the pot is light and easy to lift.

Wilhelm Wagenfeld (designer), *Glass Teapot*, Jenaer Glas, 1932

fanciful

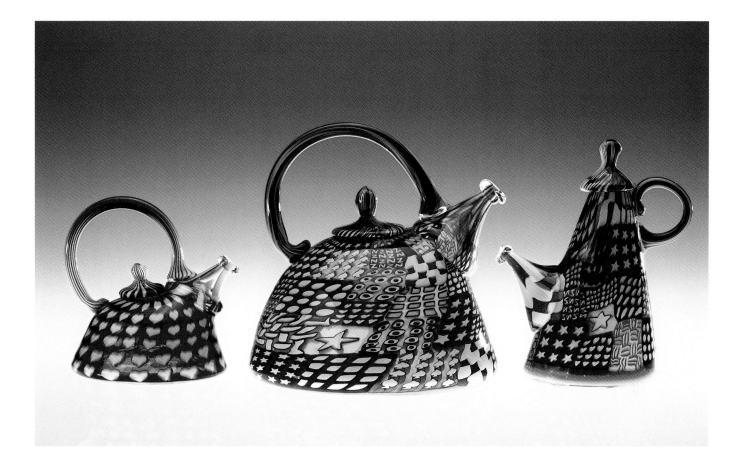

Dick Marquis's teapots are not for use: they're too precious, the glass isn't heat-resistant, and—to make the point perfectly clear—the lids don't come off. The artist is not inviting us to drink tea. He is inviting us to be enchanted by his interpretation of a traditional form, to wonder at his skill, and to bask in the loving sentiment he bestows on a domestic object.

See also transparent/translucent/opaque, vessel/sculpture

Richard Marquis, *Heart Teapot, Crazy Quilt Teapot, Crazy Quilt Coffee Pot,* 1988–90

vessel/sculpture

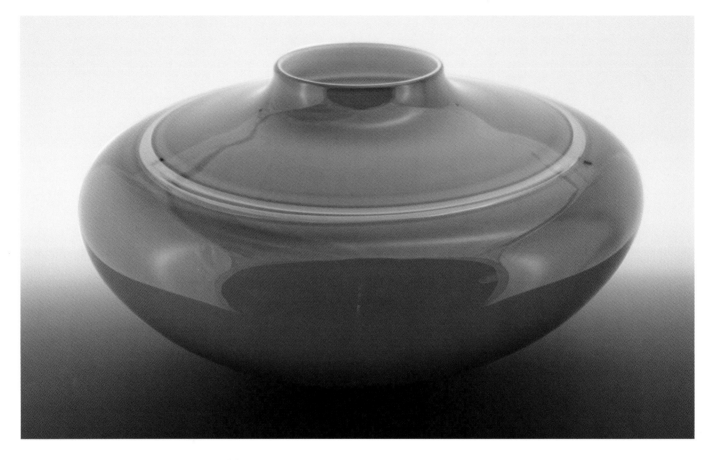

Every vessel is a link to the history of functional con—
tainers, even if it is never used for holding flowers, wine,
or other goods. Artists working in traditional craft media
(clay, fiber, glass, metal, and wood) are often drawn
to the shapes and metaphors associated with enclosed
spaces and open bowls. Sonja Blomdahl's vessel could
store grain, but its real function is to capture light.

Sonja Blomdahl, *Sienna Blue*, 2003

To oversimplify the distinction, vessels have uses;
sculptures have meaning. Ginny Ruffner's empty-
headed bird seems to be foolishly confusing money
with food. Is the artist suggesting that wealth does
not feed the mind? "Anything you see is there,"
the artist states. "I am inviting the viewer to think,
conjecture, imagine."

See also hot/warm/cold, useful/fanciful

Ginny Ruffner, *Birdbrane*, 2004

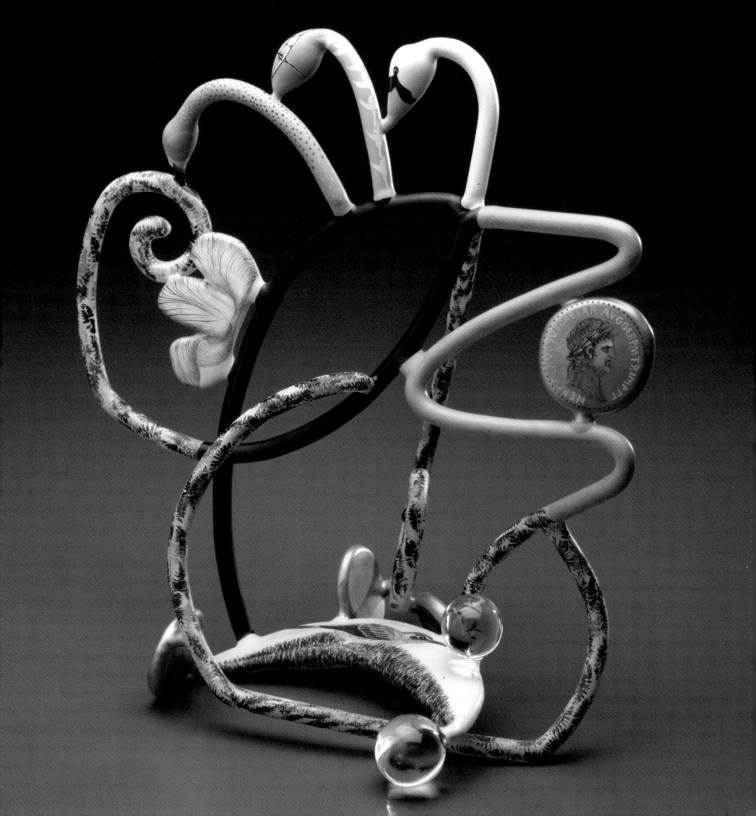

fiction

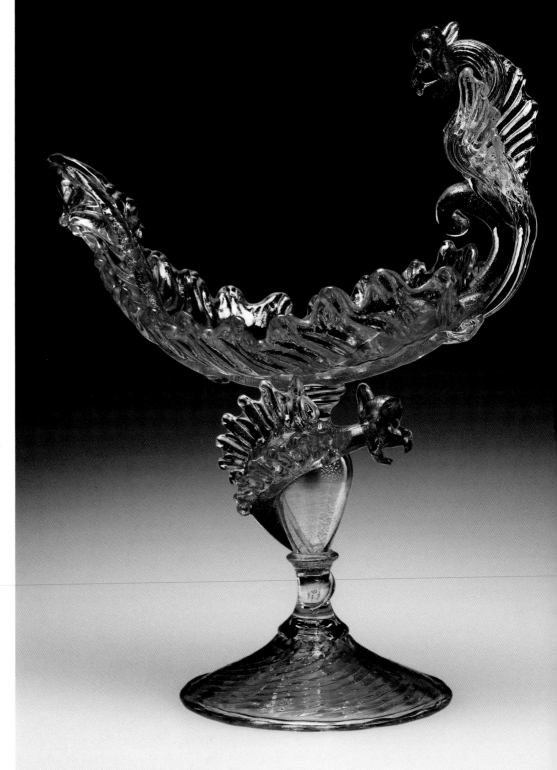

Sometimes a dragon is preferable to a squid, as a novel may be preferable to a textbook. A fondness for fiction may depend on a desire for delight rather than information, an inherently poetic rather than scientific disposition, or a mood that favors imagination over reality.

Antonio Salviati (designer), *Lettuce-Leaf Compote with Winged Griffins*, Murano, about 1880–1900

fact

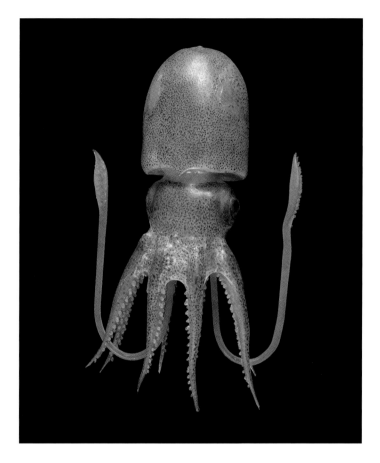

The Bohemian father-and-son team of Leopold and Rudolph Blaschka made precise models of flowers and invertebrates in clear flameworked glass, which they then painted. The models were bought by museums and schools in Europe and the United States, including Cornell and Harvard universities, for the study of specimens that cannot be easily preserved. In their work the Blaschkas combined absolute accuracy and astonishing artistry.

See also useful/fanciful

Leopold Blaschka and Rudolph Blaschka, *Unidentified Squid*, about 1880–85

craft/art

Craftsmanship refers to the mastery of skills needed to form physical objects. The laser, made by a master scientific glassblower for analyzing chemical bonds, is useless if it is not precisely formed. Manfred Langer was not seeking sheer beauty or the transmission of ideas in his creation. But can there be great craft without artistry and great art without craftsmanship?

Manfred Langer, *Laser*, about 1985

In *Table of Elements* imagination trumps precision. Jill Reynolds is intrigued by abstract systems whose parts, like atoms, come together to create meaning. She used discarded laboratory glass and other found objects to make molecular models of invented elements. The Styrofoam ball stuck with pencils, for example, depicts unlimited potential.

See also useful/fanciful, vessel/sculpture, fiction/fact

Jill Reynolds, *Table of Elements* (detail), 2003

abstract/figurative

Harvey Littleton's pink arch has bonelike proportions, with thickening at the extreme ends; it spans a void with a graceful, unbroken gesture.

When Michael Aschenbrenner, a veteran of the Vietnam War, bandages his glass bones, we link the brittleness of the medium with the vulnerability of our own bodies.

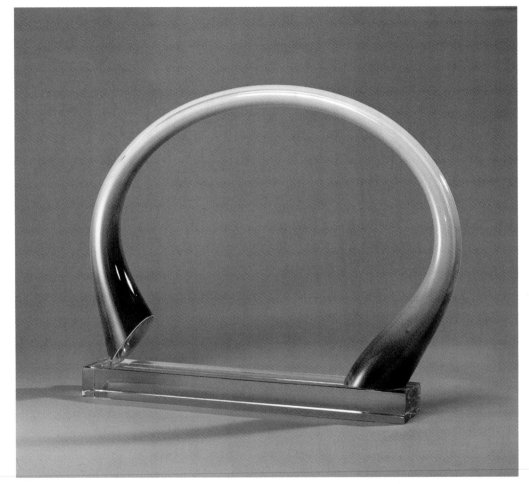

Harvey K. Littleton, *Inverted Tube/ Cut Line*, 1977

Michael Aschenbrenner, *Bones* from the *Damaged Bones Series R.V.N.*, 1980

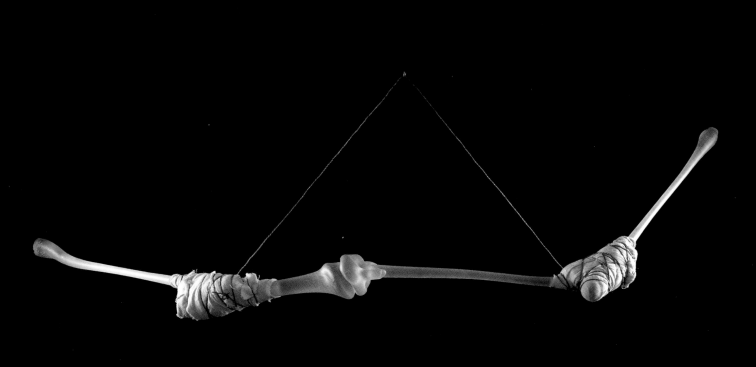

The difference between abstract art and figurative art

may be as little as a bound scrap of cloth.

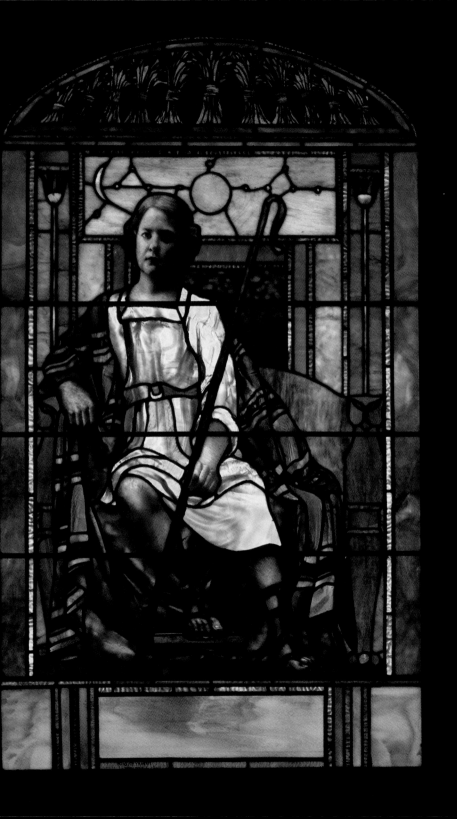

sacred

Young Joseph depicts the dreamer from Genesis in the many-colored coat given to him by his father, Jacob. He holds a shepherd's staff and is flanked by stylized lotus blossoms that refer to his sojourn in Egypt. Stained glass is often associated with biblical themes and is used in churches to tell stories, control light, and confirm an association between divinity and illumination.

Louis Comfort Tiffany (designer), *Young Joseph*, Tiffany Studios, about 1900

secular

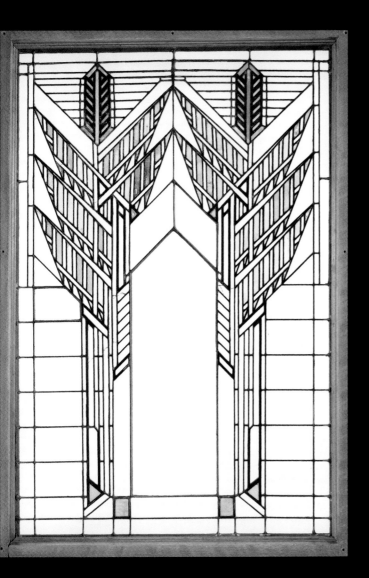

Frank Lloyd Wright's modernist window was designed at almost the same time as Tiffany's *Young Joseph*. Made for the Dana House dining room, the window depicts abstracted wheat stalks that are related to the daily activity in the room, breaking bread.

See also abstract/figurative

Frank Lloyd Wright (designer), *Sample Window for the Susan Lawrence Dana House*, about 1903

political

David Chatt writes, "While I work I listen to a lot of news, probably too much news. The issues of our times anger and frustrate me. I have often wondered what would happen if we as a society decided to choose a new model of political power and, say, put black lesbians in wheelchairs at the top of the heap, making 90 percent of the decisions that affect the rest of our lives. *White Men in Suits* isn't about that; it is about the power and privilege of the status quo."

David Chatt, *White Men in Suits*, 2002

poetic

The power of this figure resides in her character, not her bank account. The self-possession in her regal bearing plays against the receptive quality of her outstretched arms. Her garment is a similar complicated mixture of armor and lyric beauty. Sherry Markovitz says her creation is "fairytale-like, a little bit magical."

Sherry Markovitz, *Shine on Me*, 2006

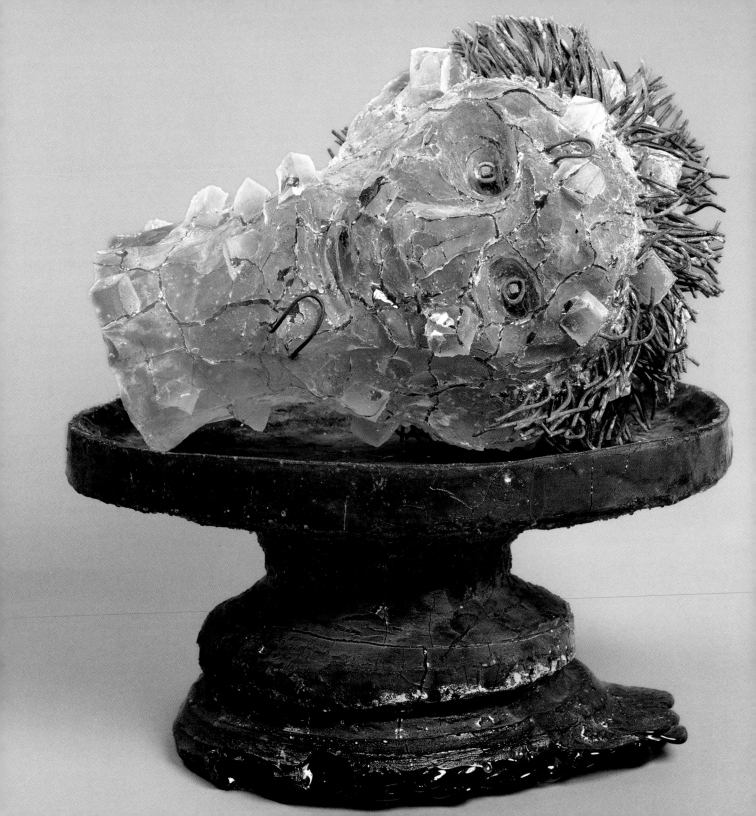

brutal/beautiful

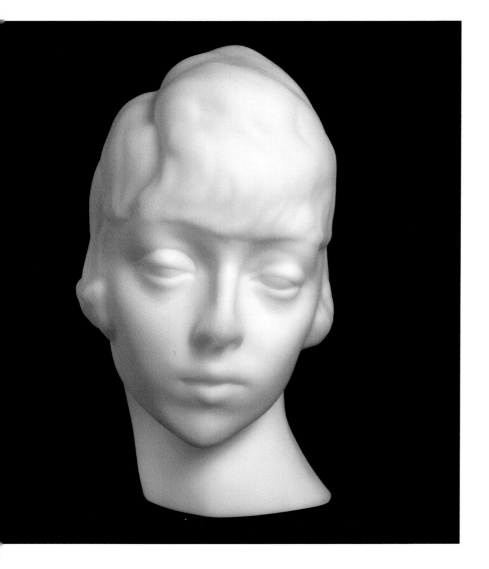

The image of a severed head on a platter usually refers to the beheading of St. John the Baptist as told in the New Testament, a gruesome subject often portrayed in European paintings. In Hank Murta Adams's version, which is lunatic as well as violent, the treatment of the glass is as brutal as the subject matter.

In this lovely head, glass is mimicking marble, the material of classical statuary of maidens and nymphs. The cast glass has been given a soft, milky quality and a skinlike sheen.

Frederick Carder (designer), *Head of a Woman*, Steuben Glass, about 1940

Hank Murta Adams, *Platterhead*, 1996

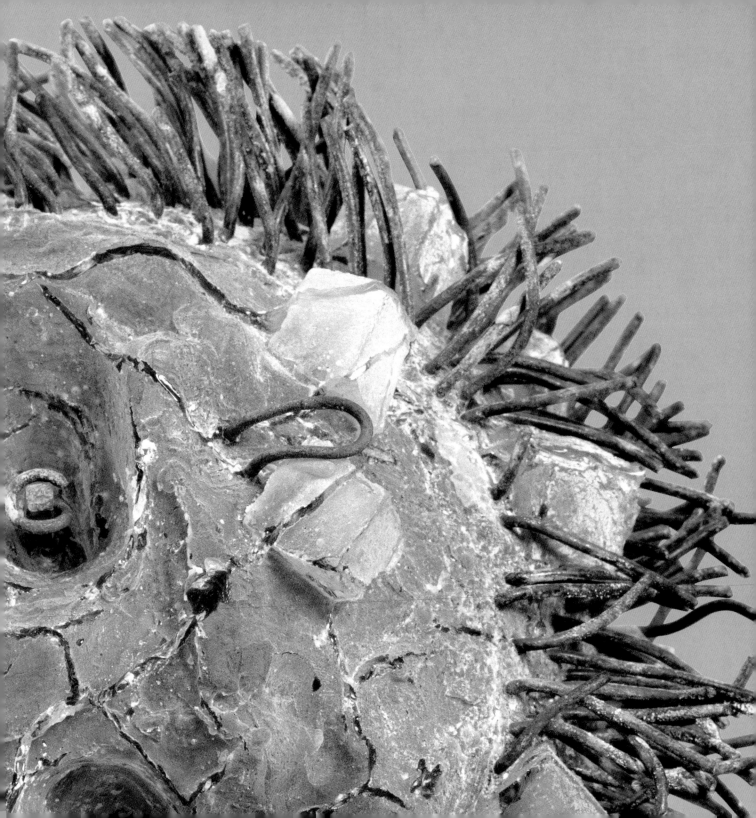

Translucent/opaque, rough/smooth,
disturbing/calming, brutal/beautiful—
all glass.

illustrations

Measurements are in inches; height precedes width precedes depth

natural pp. 8–9
Euplectella aspergillum
(skeletal detail)
Obsidian, quartz
Quartz collection of Burke Museum
of Natural History and Culture,
University of Washington
Obsidian/quartz photo
by Richard Nicol
Euplectella photo by
Joanna Aizenberg

fabricated pp. 10–11
Common glass ingredients
Photo by Richard Nicol

hot p. 12
*Jar with Two Handles
and a Lid*, Roman Empire,
1st–2nd century A.D.
Blown and tooled glass
with applied handles
28 x 5 $^3/_4$ x 5 $^3/_4$
Collection of The Corning Museum
of Glass, 54.1.5ab
Photo by Nicolas Williams, courtesy
CMOG

warm p. 14
Tom Patti (American, b. 1943)
*Solar Gray Purple Compound
with Planes*, 1981–84
Blown and laminated glass
3 $^3/_4$ x 4 x 3
Collection of the artist
Photo by Tom Patti

cold p. 15
Sidney Hutter (American,
b. 1954)
White House Vase #6, 1995
Cut, ground, polished,
and glued plate glass
18 x 10 $^1/_2$ x 10 $^1/_2$
Courtesy of the artist
Photo by Charles Mayer

transparent p. 16
Ingeborg Lundin (designer,
Swedish, 1921–1992)
Apple, Orrefors, 1957
Blown glass
14 $^3/_4$ x 13 $^3/_4$ x 13 $^3/_4$
Collection of Pam Biallas
Photo by Richard Nicol

translucent p. 18
Laura de Santillana
(Italian, b. 1955)
Sun Chariot, 2001
Blown glass
16 $^1/_4$ x 18 $^3/_4$ x 2 $^1/_4$
Collection of The Corning
Museum of Glass, 2002.3.3
Photo by Nicolas Williams,
courtesy CMOG

opaque p. 19
Richard Marquis
(American, b. 1945)
Marquiscarpa #99-16, 1999
Fused, slumped, blown,
and wheel-carved glass
20 $^1/_2$ x 24 x 7

Courtesy of the artist
Photo by Richard Marquis

rigid p. 20
Jaroslava Brychtová
(Czech, b. 1924) and
Stanislav Libenský
(Czech, 1921–2002)
Diagonal, 1989
Cast and polished glass
30 x 30 x 5 $^1/_2$
Courtesy of Heller Gallery,
New York
Photo by Steven Barall

fluid p. 21
Dale Chihuly
(American, b. 1941)
*Crystalline Clear Venetian
with Clear Coil*, 1991
Blown glass
15 x 22 x 17
Collection of Tacoma Art Museum,
gift by exchange from Rod and
Laverne Hagenbuch, Dr. and
Mrs. Shaw, and the artist
Photo by Chuck Taylor, courtesy
of Chihuly Studio

thick p. 24
René Jules Lalique (designer,
French 1860–1945)
Tourbillons, R. Lalique et Cie.,
1926
Molded and acid-etched glass
7 $^3/_4$ x 9 x 9
Collection of The Corning Museum

of Glass, gift of Dr. and Mrs.
Edward Lewison, 94.3.119
Photo by Nicolas Williams and
Andrew Fortune, courtesy CMOG

thin p. 25
Brigitta Karlson (designer,
Swedish, b. 1945) and
Ove Thorsson (designer,
Swedish, b. 1943)
Reticello Bowl, Venini
Glassworks, 1972–74
Blown glass
4 $^3/_4$ x 11 $^3/_4$
Collection of The Corning
Museum of Glass, gift of Venini
Glassworks, 79.3.71
Photo by Nicolas Williams and
Andrew Fortune, courtesy CMOG

heavy p. 26
Robbie Miller
(Canadian American, b. 1955)
Block, 2000
Kiln-cast lead crystal
15 $^1/_2$ x 7 $^1/_2$ x 7
Courtesy of the artist and
William Traver Gallery, Seattle
Photo by Russell Johnson

light p. 29
Susan Plum
(American, b. 1944)
*Metamorphosis Series:
Tejidos XIII*, 1997
Flameworked glass
35 $^1/_2$ x 51 $^1/_2$ x 14

Collection of Anne Gould Hauberg
Photo by Richard Nicol

painted p. 30
Walter Lieberman
(American, b. 1954)
La Reina de las Campesinas,
1995
Enamel and gold leaf
on blown glass
12 $^3/_4$ x 10 $^3/_4$ x 5 $^3/_4$
Collection of Anne Gould Hauberg
Photo by Richard Nicol

engraved p. 31
Vicke Lindstrand (designer,
Swedish, 1904–1983)
Indian Chief Vase,
Orrefors, 1937
Cut and engraved glass
12 $^3/_4$ x 7 x 3 $^3/_4$
Collection of Pam Biallas
Photo by Richard Nicol

form p. 32
Flora C. Mace (American,
b. 1949) and Joey Kirkpatrick
(American, b. 1952)
Water Catcher, 1984
Enamel on blown glass
and wood, wire
37 x 6 x 6
Collection of The Corning
Museum of Glass, 85.4.3
Photo by Nicolas Williams,
courtesy CMOG

surface p. 33
Flora C. Mace (American,
b. 1949) and Joey Kirkpatrick
(American, b. 1952)
Doll Drawing, 1981
Glass frit and wire
on blown glass
17 $^1/_2$ x 15 x 15
Collection of Anne Gould Hauberg
Photo by Richard Nicol, courtesy
of Methodologie

free-blown p. 34
H. Gaige
(English, dates unknown)
*Wine Bottle with Seal of
H. Gaige*, 1712
Blown glass with
applied decoration
5 x 5 $^1/_4$ x 5 $^1/_4$
Collection of The Corning
Museum of Glass, 71.2.10
Photo by Nicolas Williams and
Andrew Fortune, courtesy CMOG

mold-blown p. 34
*Flask with Portraits of George
Washington and Zachary
Taylor*, Dyottville Glass Works,
Philadelphia, about 1847–48
Mold-blown glass
H. 7
Collection of The Corning
Museum of Glass, 60.4.39
Photo by Nicolas Williams and
Andrew Fortune, courtesy CMOG

machine-blown p. 35
*Straight-Sided Coca-Cola
Bottle*, 1910–19
Mold blown in automated
bottle-blowing machine
7 x 2 x 2
Collection of The Corning
Museum of Glass, 65.4.92
Photo by Nicolas Williams and
Andrew Fortune, courtesy CMOG

factory p. 36
Nils Landberg (designer,
Swedish, 1907–1991)
Tulip Goblet and Vase,
Orrefors, about 1957
Blown glass
Goblet: H. 17; vase: H. 17
Collection of Pam Biallas
Photo by Richard Nicol

studio p. 38–39
Harvey K. Littleton
(American, b. 1922)
Vase with Expanded Prunts,
1965
Blown glass
H. 6 $^1/_4$
Collection of the artist
Photo by Dan Durrance,
Littleton Studios

Russell Day
(American, b. 1912)
Untitled, 1965
Blown glass
6 $^1/_2$ x 4 $^3/_4$ x 4 $^3/_4$

Collection of Anne Gould Hauberg
Photo by Richard Nicol

creator p. 40
Dante Marioni
(American, b. 1964)
Yellow and Blue, 2002
Blown glass, wood
31 x 19 x 5 $^1/_2$
Courtesy of the artist
Photo by Roger Shcreiber

designer p. 41
Dante Marioni (designer,
American, b. 1964)
*Goblets from the Counterpoint
Collection*, Steuben Glass,
2003
Mold-blown glass bowls, press-
molded glass stems and feet
Tallest: H. 10 $^1/_4$
Courtesy of Steuben Glass
Photo by Robert Moore

useful p. 42
Wilhelm Wagenfeld (designer,
German, 1900–1990)
Glass Teapot, Jenaer Glas,
1932
Free-blown glass spout
and handle, mold-blown
glass body, pressed glass
strainer and lid
5 $^1/_4$ x 4 $^1/_2$ x 3
Museum of Glass, purchase

fanciful p. 43
Richard Marquis
(American, b. 1945)
Heart Teapot, 1988
Crazy Quilt Teapot, 1990
Crazy Quilt Coffee Pot, 1990
Blown murrine glass
Tallest: H. 5 1/$_2$
Collection of
Johanna Nitzke Marquis
Photo by Richard Marquis

vessel p. 44
Sonja C. Blomdahl
(American, b. 1952)
Sienna Blue, 2003
Blown glass
8 1/$_4$ x 15 1/$_4$ x 15 1/$_4$
Museum of Glass,
gift of the artist

sculpture p. 45
Ginny Ruffner
(American, b. 1952)
Birdbrane, 2004
Flameworked and painted
glass, mixed media
14 x 14 x 10
Courtesy of the artist and Maureen
Littleton Gallery, Washington, D.C.
Photo by Mike Seidl

fiction p. 46
Antonio Salviati (designer,
Italian, 1816–1890)
*Lettuce-Leaf Compote with
Winged Griffins*, Murano,

about 1880–1900
Blown and hot-worked glass,
gold foil
11 3/$_4$ x 9 1/$_2$ x 6
Collection of The Corning Museum
of Glass, gift of Barry Friedman Ltd.,
New York, 2005.3.36
Photo by Nicolas Williams and
Andrew Fortune, courtesy CMOG

fact p. 47
Leopold Blaschka
(German, 1822–1895) and
Rudolph Blaschka
(German, 1857–1929)
Unidentified Squid,
about 1880–85
Painted flameworked glass
1 1/$_4$ x 4 5/$_8$ x 3
Collection of Museum of
Science, Boston
Photo by Eric Workman,
courtesy Museum of Science

craft p. 48
Manfred Langer
(German American, b. 1939)
Laser, about 1985
Flameworked and
latheworked glass
7 x 55 x 3
Museum of Glass, gift of the artist
Photo by Richard Nicol

art p. 49
Jill Reynolds
(American, b. 1956)
Table of Elements (detail),
2003
Flameworked glass, altered
labware, mixed media
60 x 60 x 74
Courtesy of the artist
Photo by Richard Nicol

abstract p. 50
Harvey K. Littleton
(American, b. 1922)
Inverted Tube/Cut Line, 1977
Blown glass
13 1/$_8$ x 16 1/$_4$
The Corning Museum of Glass,
gift of Harvey K. and Bess Littleton,
82.4.76
Photo by Nicolas Williams,
courtesy CMOG

figurative p. 51
Michael Aschenbrenner
(American, b. 1949)
Bones from the *Damaged
Bones* Series R.V.N., 1980
Hot-worked and sandblasted
glass, cloth, wire
22 1/$_4$ x 31 1/$_2$ x 3 1/$_2$
Collection of The Corning Museum
of Glass, purchased with the aid of
funds from the National Endowment
for the Arts, 80.4.53
Photo by Nicolas Williams and
Andrew Fortune, courtesy CMOG

sacred p. 52
Louis Comfort Tiffany
(designer, American,
1848–1933)
Young Joseph, about 1900
Tiffany Studios
Multicolored, cut,
and leaded glass
69 1/$_2$ x 39 framed
Collection of The Corning Museum
of Glass, gift of Dr. Robert Koch,
64.4.80
Photo by Ray Errett and Nicolas
Williams, courtesy CMOG

secular p. 53
Frank Lloyd Wright (designer,
American, 1867–1959)
*Sample Window for the
Susan Lawrence Dana House*,
Springfield, Illinois,
about 1903
Cut and leaded glass
46 1/$_2$ x 31 1/$_2$
The Richard W. Bock Sculpture
Museum, Greenville College,
Greenville, Illinois
Photo by Allied Photocolor, St. Louis,
courtesy Greenville College

political p. 54
David Chatt
(American, b. 1960)
White Men in Suits, 2002
Glass beadwork and
U.S. currency
28 x 12 x 12

Collection of the artist
Photo by Harriet Burger

poetic p. 55
Sherry Markovitz
(American, b. 1947)
Shine on Me, 2006
Beadwork and found objects
on paper mache and fabric
36 x 18 x 18
Courtesy of the artist and
Greg Kucera Gallery, Seattle
Photo by Eduardo Calderón

brutal p. 56
Hank Murta Adams
(American, b. 1956)
Platterhead, 1996
Cast glass, patinated copper
19 x 20 x 17
Collection of Tacoma Art
Museum, gift of Rebecca and
Alexander C. Stewart
Photo by Richard Nicol

beautiful p. 57
Frederick Carder (designer,
British, 1863–1963)
Head of a Woman,
Steuben Glass, about 1940
Cast glass
H. 11
Collection of The Corning
Museum of Glass, 59.4.384
Photo by Nicolas Williams,
courtesy CMOG

Chambers, Karen S., and Tina
Oldknow. *Clearly Inspired:
Contemporary Glass and Its
Origins*. Tampa, Fla.: Tampa
Museum of Art, 1999.

Fox, Howard. *Glass: Material
Matters*. Los Angeles: The Los
Angeles County Museum of
Art, 2006.

Frantz, Suzanne K.
*Contemporary Glass: A World
Survey from The Corning
Museum of Glass*. New York:
Harry N. Abrams, 1989.

Klein, Dan. *Artists in Glass:
Late Twentieth Century Masters
in Glass*. London: Octopus
Publishing Group, 2001.

Klein, Dan, and Ward Lloyd,
eds. *The History of Glass*.
London: Orbis, 1984.

Lynn, Martha Drexler.
*American Studio Glass,
1960–1990*. New York and
Manchester: Hudson Hills
Press, 2004.

Oldknow, Tina. *Pilchuck: A
Glass School*. Seattle: Pilchuck
Glass School in association
with University of Washington
Press, 1996.

Opie, Jennifer Hawkins.
*Contemporary International
Glass*. London: V & A
Publications, 2004.

Tait, Hugh, ed. *Five Thousand
Years of Glass*, rev. ed.
Philadelphia: University of
Pennsylvania Press, 2004.

Warmus, William. *Fire and
Form*. West Palm Beach, Fla.:
Norton Museum of Art, 2003.

Whitehouse, David. *The
Corning Museum of Glass: A
Decade of Glass Collecting,
1990–1999*. Corning, N.Y.:
The Corning Museum of Glass,
2000.

contrasts: a glass primer

Organized by the Museum of Glass

Sponsored by the Ben B. Cheney Foundation, the Gottfried and Mary Fuchs Foundation, and the *Seattle Times* and the *Seattle Post-Intelligencer*

Frontispieces: Dante Marioni, *Yellow and Blue* (detail), 2002; Dante Marioni (designer), *Goblets from the Counterpoint Collection* (detail), Steuben Glass, 2003

This book is published in conjunction with the Museum of Glass exhibition *Contrasts: A Glass Primer*.

© 2007 by the University of Washington Press

Printed in China

Design by Michelle Dunn Marsh

12 11 10 09 08 07 5 4 3 2 1

Library of Congress Cataloging-in-Publication Data
Halper, Vicki.
 Contrasts : a glass primer / Vicki Halper. — 1st ed.
 p. cm.
Issued in connection with an exhibition held at the Museum of Glass.
ISBN-13: 978-0-295-98722-4 (pbk. : alk. paper)
ISBN-10: 0-295-98722-7 (pbk. : alk. paper)
1. Glassware — Handbooks, manuals, etc. 2. Glass — Handbooks, manuals, etc. I. Museum of Glass: International Center for Contemporary Art. II. Title.
NK5104.H35 2007
748—dc22
 2007008273

The paper used in this publication is acid-free and 90 percent recycled from at least 50 percent post-consumer waste. It meets the minimum requirements of American National Standard for Information Sciences — Permanence of Paper for Printed Library Materials, ANSI Z39.48–1984.

Museum of Glass
1801 Dock Street
Tacoma, WA 98406-3217
www.museumofglass.org

University of Washington Press
PO Box 50096
Seattle, WA 98145
www.washington.edu/uwpress